SEASCAPES
& SUNSETS

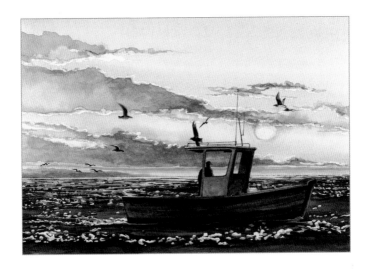

By Thomas Needham

www.walterfoster.com

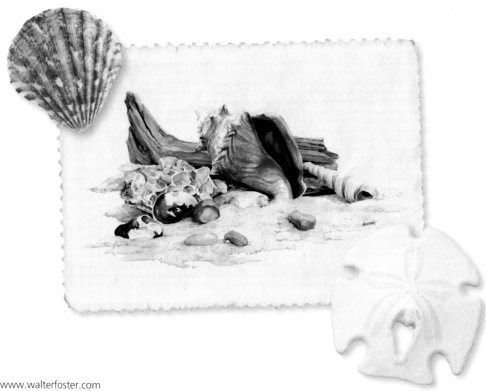

www.walterfoster.com
3 Wrigley, Suite A
Irvine, CA 92618

Author: Thomas Needham
Project Manager: Lindsay Horvath
Designer: Shelley Baugh
Production Artist: Debbie Aiken
Associate Publisher: Elizabeth T. Gilbert
Managing Editor and Licensing Coordinator: Rebecca J. Razo
Associate Editor: Emily Green
Production Manager: Nicole Szawlowski
International Purchasing Coordinator: Lawrence Marquez

Printed in China
10 9 8 7 6 5
19065

CONTENTS

Introduction. 4

Tools & Materials . 5

Additional Materials. 7

Basic Watercolor Techniques . 8

Seascape Elements & Techniques. 10

Guidelines & Tips. 13

Sunset Techniques. 14

Exploiting the Sunlight. 16

Painting from a Different Angle . 20

Rendering Small Details . 24

Mixing References & Imagination . 28

Adding Shadows . 32

Omitting the Unnecessary . 36

Rendering the Coastline. 40

Painting from Imagination. 44

Changing the Scenery. 48

Overcoming Fear. 52

Capturing the Moment. 56

Painting in Sections. 60

Final Thoughts. 64

INTRODUCTION

Salty air, screeching gulls, crashing breakers, and golden, rippling waves. It was my good fortune to grow up on the beaches of Southern California, a paradise where I could observe a kaleidoscope of colors. From beautiful sunsets to walks on sandy beaches, I was fortunate enough to experience the raw energy of the sea on a daily basis.

As a watercolorist, I find the sky and sea inspiring yet challenging subjects to paint. With this book, I hope to pass along my passion for this art form. We'll start with techniques for basic washes and textures and then we'll move to painting luminous skies and various elements found in seascapes, such as rocks, sea grass, and ocean foam. Through a series of projects, I'll demonstrate how a painting is executed from start to finish using a step-by-step approach. In the process you will learn about masking, selecting a palette, mixing colors, capturing a moment in time, and creating a mood.

I hope you find the information contained in this book inspiring and helpful in developing your watercolor skills. Do not be afraid to make mistakes and remember that success is built upon failure. Be bold!

Now get out your brushes and have some fun!

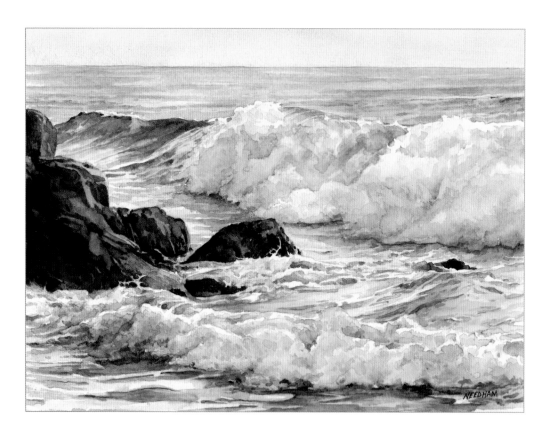

TOOLS & MATERIALS

If you are new to watercolor painting, sorting through all the available products in printed catalogs and online stores can be daunting. Instead of comparing various materials and brands, I am going to keep it simple by telling you what I use and why.

Personal preferences aside, here are a couple of shopping tips: Avoid the very cheapest materials and purchase the best you can afford. Better-quality materials last longer and produce more vibrant results. Also, it's a good idea to research the pricing of art materials online as well as at your local art and craft store.

Watercolor Surfaces

There are three basic surfaces for watercolor papers or boards: hot press (smooth), cold press (semi-rough), and rough (heavily-textured). Most artists prefer the more versatile semi-rough surface.

I prefer watercolor board for its pure white surface, durability, and archival quality. It proves more stable when working wet-into-wet because pigments of color do not pool in unwanted areas (this often happens with paper). Another advantage to watercolor board is that one can rinse off an unsuccessful wet-into-wet-wash in the sink and try again. Earth tones generally rinse off easily, whereas phthalocyanine blues and greens are harder to remove because they tend to stain the rag fibers. Please note that rinsing the board cannot be done indefinitely. Over-washing will separate the surface layer from the substrate.

Should you choose to paint on watercolor paper, I suggest working with 140 lb to 300 lb papers. Be careful with the softer and cheaper papers, for many are made from wood pulp that is susceptible to tearing when removing masking fluid. In addition, watercolor papers vary in whiteness. Some even have a vanilla tint to them, so if you are painting a scene that requires white (such as a snow scene), keep this in mind.

Brushes

One of the quickest ways to improve your watercolor skills is to use quality brushes, such as sable brushes. They hold a good quantity of pigment, have the capacity to release the color in an even flow, and have tips that return to a fine point. Unfortunately, sable brushes are not cheap, but if properly cared for, these brushes can be a one-time purchase. However, avoid using them with other paint mediums such as oil and acrylic.

Aside from sable, there are less expensive watercolor brushes available, such as synthetic brushes, which are made of nylon or a mixture of nylon and sable. I do not recommend these, though, because they do not hold the paint as well as natural sable.

The good news is that you do not need a lot of brushes to get started. An array of seven brushes should provide an adequate stash to get you painting. The three brushes I use the most are my 1" flat, #7, and #4 round. I recommend building a set of brushes around these three, and perhaps adding a 1/2" flat, 1/4" flat, #1 round, and a fan brush.

Paint

Watercolors come in tubes or small pans (also called cakes). I prefer the moist, professional-quality paint that comes in tubes because it is easier to mix large quantities of color for washes. These are not cheap, but you'll be astonished at how long a tube will last.

My basic palette includes these colors: Naples yellow, yellow ochre, raw sienna, cadmium orange, burnt sienna, scarlet lake, cadmium red, alizarin carmine, mauve, ultramarine blue, cobalt blue, cerulean blue, cobalt turquoise, sap green, Hooker's green, and burnt umber. I also have a tube of white gouache that I use for certain effects, such as sea spray or snowflakes. Do not mix the gouache on your watercolor palette or with watercolor paints, for it will turn your colors chalky and milky.

Mixing Palette

I use a large 19" x 13" white porcelain butcher's tray as a mixing palette. I arrange my colors along the outside edges of the tray, reserving a large area in the center for mixing colors. It is important that a palette have ample area in which to mix colors. If you're serious about painting, stay away from the small round palettes and never use any type of craft foam (polystyrene) as a palette; the paint beads up, making it impossible to mix a desired color or wash. You may decide to use a large tray for big washes and a medium tray for rendering.

ADDITIONAL MATERIALS

- Pencils for sketching (Most of the time, I use a 2H to a 4H pencil. I like a hard lead pencil because it holds a fine point longer and leaves a lighter mark on your paper or board, as long as you are not heavy-handed with it. The graphite from softer pencils has a tendency to smear or contaminate light, bright colors like yellow.)
- A kneaded eraser for removing unwanted pencil lines from a finished painting
- Masking fluid for masking out intricate details, areas that would be difficult to paint around, or white areas that need protecting
- Masking tape for masking off and blocking in the area to be painted, which leaves a clean edge around the finished painting
- Tracing paper for transferring more complicated sketches onto the watercolor surface
- A craft knife for adding small details, such as blades of grass or reflections on water (I prefer a #11 blade.)
- A box knife for cutting large watercolor board into smaller, more manageable sizes
- A toothbrush for creating textures using the splatter technique
- Cotton swabs for softening edges of color
- A sea sponge for lifting color, softening edges, and creating clouds
- A ruler for obtaining straight lines
- Matches or a lighter for loosening up paint tube caps
- A water container (An empty plastic container or jar will work. Make sure it's large enough to hold plenty of clean water.)
- Paper towels for cleaning up and drying your brushes
- A tote bag for storing your painting supplies (A tackle box works well.)

Setting Up a Studio The majority of my painting is done in the studio. When painting in watercolor, I like to work on a flat surface because it is the easiest way to control washes. Since I am right-handed, my palette and water containers are always on my right side. Lighting is extremely important, especially if painting at night. Always use color-balanced light sources such as natural light, halogen bulbs, or studio lamps with a warm light bulb.

BASIC WATERCOLOR TECHNIQUES

The next few pages will introduce you to some basic tips and techniques for handling watercolor paint. The richness and uniqueness of transparent watercolor is that it requires much water and very little concentrated watercolor pigment—a characteristic that is lost on many beginning students. The following are basic watercolor washes and techniques for creating various textural effects.

Washes

Flat Wash A flat wash is one color applied evenly to the surface of the watercolor paper or board. It can be achieved using either a *wet-into-wet* method or a *wet-onto-dry* method. To achieve the wet-into-wet method, first wet the surface. Next, apply a brush loaded with paint to the surface, moving it side to side and working from top to bottom in an even and continuous manner. This makes it possible to create a seamless and uniform value without any evidence of individual brushstrokes. Wet-onto-dry refers to applying wet color onto a dry surface.

Gradient Wash A gradient wash is one color that changes gradually from dark to light, as seen in a sky. It starts out much like a flat wash, but as the wash progresses, water is added to the mix with clean, wet brushstrokes in succession, which dilutes and lightens the color toward the horizon. Work quickly, slightly overlapping each brushstroke as you move down the wash. Be sure to drag your brush across the entire width of the area you want covered.

Variegated Wash Variegated washes are great for executing luminous and dramatic skies, particularly sunsets. Using the wet-into-wet method, start by wetting the entire surface area. Working rapidly, apply the warm colors first and then the cool colors. You can control the amount that one color bleeds into another by tilting the painting at different angles and adjusting the amount of water utilized.

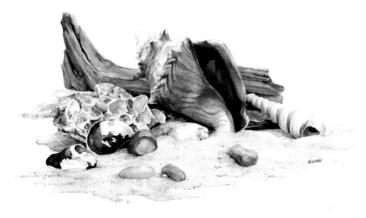

Layering/Glazing Layering of one transparent color over another is accomplished in stages to build depth. The first color is applied to the board or paper and is allowed to dry. With the first color *thoroughly* dry, you can apply the next color. A quick, wet brushstroke of color over the first layer will result in a luminous effect. If you saturate or agitate the surface too much, the end result will look muddy. In the watercolor of beach shells at left, much of the rendering was done using layering.

Masking I often employ this technique in my paintings. It is by far the easiest way to save and protect a pristine white surface before applying color. When using masking fluid, always use cheap, old, disposable brushes. It is also handy to have a rubber-cement-pick-up for removing masking fluid from the surface of the paper.

Scratching I use this technique when I need fine lines, such as blades of grass. First wet the area to be worked on; then lay down a wash of the desired color(s). While the area is still wet I begin scratching rapidly with a craft knife. The value of the lines can be controlled based on when you scratch. For darker lines, scratch the surface while it's still very wet. For medium value lines, scratch when the surface is damp. For your lightest lines, scratch when the surface is nearly dry. The same craft knife can be used to scrape tiny, bright sparkles onto the water or spray from a breaking wave.

Splattering Need to add some texture to your painting? Load an old toothbrush with paint, strum your finger across the bristles, and fine dots will splatter like snow onto your board. This is an especially great technique for creating sand or snowflakes. For snow, apply white gouache onto a dry surface. I recommend practicing this technique a few times before applying it to a nearly completed painting, and be sure to cover areas you do not want speckled.

Split Brush I use this technique primarily to create wood grain. To achieve this texture, simply press or mash a flat brush into the palette of color, which spreads the hairs into fingers; then drag the brush very lightly across the wooden area.

SEASCAPE ELEMENTS & TECHNIQUES

On the following three pages, you will discover how to paint common elements indigenous to seascapes. The steps in these demonstrations utilize basic watercolor techniques that you will encounter in the project portion of this book.

Seafoam

Step 1: Sketch and Mask Using a 2H pencil, sketch in detail the delicate lace pattern of the sea foam. Once the drawing is complete, mask out the sea foam in order to preserve the clean, white surface.

Step 2: The Wash When you are finished with the wash, remove the masking. Using a round brush, apply a wet-into-wet-wash over the sand and seawater. Tackle the sand using a mix of burnt umber, ultramarine blue, cerulean blue, and a touch of mauve. For the seawater, use cerulean, cobalt, and ultramarine blues, cobalt turquoise, and mauve. Add touches of burnt sienna and yellow ochre to the shallow water areas.

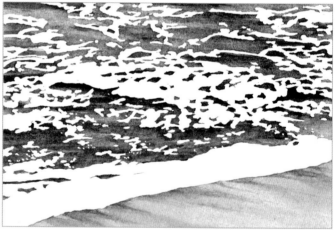

Step 3: Finishing Touches Apply a light wash of cobalt blue and mauve over the lace pattern of the sea foam to subdue some of the bright white.

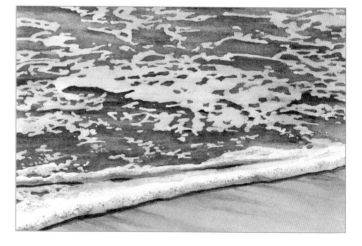

Rocks

Step 1: Sketch Using your imagination, create a contour line drawing of rocks using a 2H pencil.

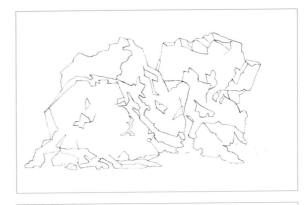

Step 2: Initial Wash Begin giving your rocks some form and color. Using the wet-onto-dry method, apply a light wash of Naples yellow over the rocks. Once the initial wash is dry, come back with a wash of burnt sienna to give the rocks shadows and shape.

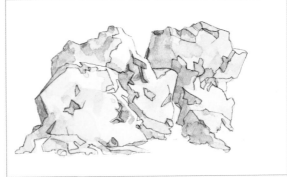

Step 3: Layering Continue to layer wash over wash with various colors such as ultramarine blue, burnt umber, scarlet lake, and mauve to further define and shape the rocks.

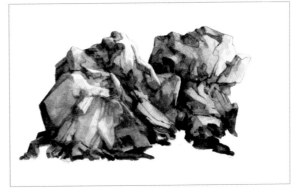

Step 4: Soften Edges and Finishing Touches Finish by adding some surf lapping up onto the rocks. To soften the edges and achieve a bit of transparency, apply a small amount of water where the surf meets the rocks and then remove some of the pigment with a cotton swab. Lastly, using white gouache, paint streams of water running and bits of wave spray exploding off the rocks.

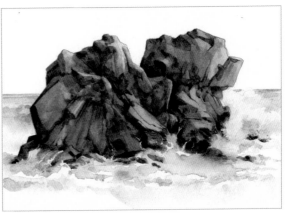

Surf

Step 1: Sketch and Mask Make a rough line sketch of surf and rocks. Next, mask out the crashing surf and rocks, taking care to mask tiny droplets of spray flying through the air.

Step 2: Initial Wash When the masking fluid is dry, fill the sky using a variegated wash of cobalt blue, ultramarine blue, and a bit of cadmium red near the horizon. Once the sky is dry, begin to brush in a wash for the ocean using cerulean, cobalt, and ultramarine blues, cobalt turquoise, and cadmium red.

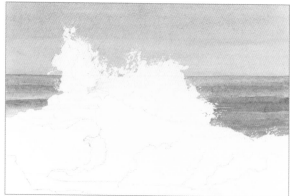

Step 3: Rendering Before rendering the crashing surf, remove the existing mask and re-mask a few small areas in the foam. Pick a section of the splash or surf and work wet-into-wet in small areas. Dropping small amounts of blues, greens, and purples into the wet areas, let the colors bleed into one another. Give the rocks some structure by laying in various shades of blues and burnt umber.

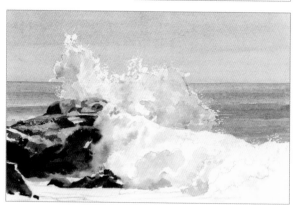

Step 4: Finishing Touches Next, remove the masking from the highlighted surf areas. Take a wet cotton swab or brush and hit the edges where the surf meets the rock to soften the edges and create some transparency.

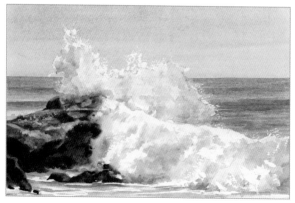

GUIDELINES & TIPS

Before starting a series of step-by-step watercolor projects and taking that initial first step of applying water and pigment to an austere painting surface, let's go over some fundamental concepts that apply to visual art. Most importantly—think! Have a clear objective for your painting and don't just push the paint around. Be deliberate and confident with your creativity, and always have a good reason for doing what you're doing. Below are lists of basic, time-tested artistic conventions. Read them over, think about them, and then get to work! Your creativity is the limit!

WATERCOLOR RULES OF THUMB

1. Work from light to dark.

2. Work from the background to the mid-ground to the foreground.

3. When painting wet-into-wet washes, work rapidly.

4. Keep in mind that watercolors dry lighter than they appear when wet.

GENERAL PAINTING RULES OF THUMB

1. Use the appropriate brush or tool for the job.

2. Don't be afraid to add or subtract an object from your painting.

3. Something should dominate your painting. Whether it be the sky, a wave, a boat, or a flock of seagulls, a particular element should dictate the purpose of your artwork.

4. For drama, make a commitment to create a primarily warm or cool, dark or light composition.

5. If it is easily visible in your painting, the placement of the horizon is important. The last place it should be is in the center of the painting because this divides the painting half.

6. Place large shapes in the foreground, medium size shapes in the midground, and smaller shapes in the distance.

7. Objects in the foreground are darker with more contrast, becoming lighter with less contrast as they fade into the distance.

8. Rough texture gives the illusion of close detail, so use it in the foreground. Smooth texture is great for the midground, and soft texture has little or no detail, so use it for the background.

9. Keep the foreground simple. If it's too detailed, it can take over the painting and provide unwanted competition for the dominant subject.

10. Use converging or curving lines to lead the eye to the dominant subject.

SUNSET TECHNIQUES

Sunsets are all about the colors in the sky. In most seascapes or landscapes, the sky sets the mood and dictates the color scheme of the entire composition. The best way to paint a sky in watercolor is to use a wet-into-wet variegated wash. Having executed myriad wet-into-wet-washes myself, I can now feel confident of the outcome. However, mastering the art of wet-into-wet-washes requires a lot of patience, perseverance, and—most of all—practice. I embrace the challenge of painting sunsets that involve more than four colors, for the end result is a clean, glorious color.

With wet-into-wet-washes, the wet painting surface creates fluid runs, exciting mixtures, and soft gradations of color, which capture the softness of clouds and sky. However, achieving pillow-soft edges is no easy feat. If the surface or paintbrush are soaking wet, you lose control over the color. If they are too dry, the color will not spread. The following illustrations are examples of wet-into-wet washes that show various cloud formations and color schemes.

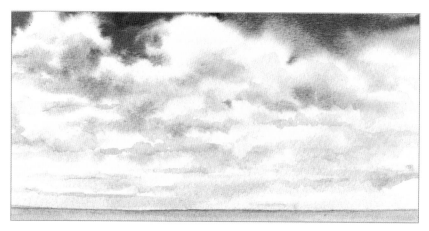

Late Afternoon Painting fluffy white clouds in watercolor requires painting the sky and not the clouds. Using a wet-into-wet wash, I began at the top with ultramarine blue and worked down the painting, introducing cobalt blue and cerulean blue as I went. Clouds appear larger at the top of the painting and shrink as they near the horizon. To give the clouds some dimension, I mixed a gray value and applied it to their undersides. The temperature of the afternoon can be controlled through color. For a warm afternoon, spike the water with a touch of lemon yellow and paint light blues. For a cooler afternoon, use stronger and darker blues.

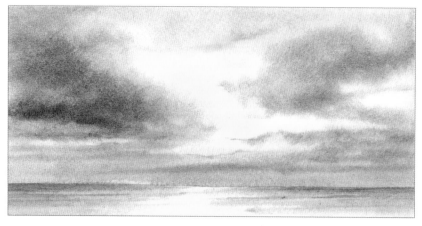

Hazy I used four colors (ultramarine and cobalt blue, raw sienna, and cadmium red) in a wet-into-wet wash to depict the sun breaking through a bank of hazy clouds. To form the clouds, use the ultramarine and cobalt blues and cadmium red. For the sun, add raw sienna and allow it to bleed and blend, giving a soft, hazy feel to the day.

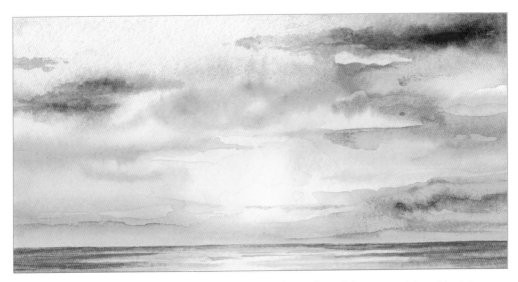

Blazing Here the sky is on fire using a wet-into-wet wash of myriad colors: lemon yellow, cadmium orange, cadmium red, burnt sienna, cobalt blue, and ultramarine blue. With the exception of the sun's center, the entire board was wet upon application of the paint. I surround the sun with lemon yellow, allowing it to spread out in all directions. I placed a light coating of ultramarine and cobalt blues at the top of the board and allow them to bleed down. To form clouds, I layer mixtures of cadmium orange, burnt sienna, and cadmium red over the initial wash.

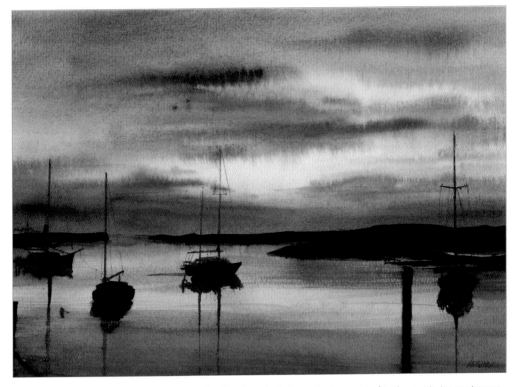

Dusk This painting captures the end of day. The sun has slipped over the horizon and only remnants of its glow remain. In a wet-into-wet wash, I applied the warm colors of the glow first followed by the cool blues.

EXPLOITING THE SUNLIGHT

I wanted this project to be challenging, so I searched my files for the perfect reference photo. I found what I was looking for in this picture of rolling surf in a cove just south of Point Mugu in Southern California. For me, there is no greater challenge than to paint a sunset and get all of the colors to blend perfectly. To make the composition more intimate, I used only a portion of the reference photo. I decided to give the sky more drama by warming up the color and changing the time of day to late afternoon.

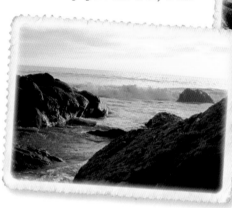

Palette

burnt sienna, burnt umber, cerulean blue, cobalt blue, cobalt green, mauve, Naples yellow, scarlet lake, ultramarine blue

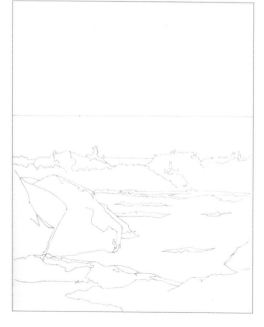

Step 1 Using a pencil, lightly draw the horizon line first, and then add the main elements in the painting: rolling surf, rocks, and a few dark waves. When the drawing is finished, mask off a one-inch strip below the horizon line.

Tip

When painting with watercolors, a good sketch is essential. Oils and acrylics are forgiving; if you find yourself unhappy with the placement of an object, you can move it by painting over it. In watercolor, however, moving elements around like this is not an option. The paint is simply not thick enough to cover mistakes.

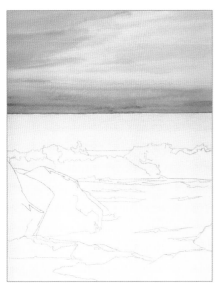

Step 2 Working rapidly, apply clean water to the entire sky area with a flat brush. Start with a very light wash of Naples yellow. Next, load the same color onto a large round brush and apply it to the bottom third of the sky, taking care to add some to the outer edges of the clouds. Clean the brush and add burnt sienna to the lower portion of the sky and the clouds in the upper portion of the sky. Place horizontal strokes of cobalt blue in the upper sky followed by a mix of cobalt and mauve for the main body of clouds. For the finishing touches, add a few strokes of scarlet lake to the bottom of a few clouds. Once the sky is completely dry, remove the masking.

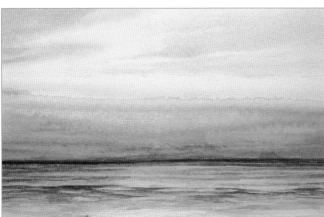

Step 3 First, mask off the top part of the breaking wave. Add a wash of Naples yellow over the entire ocean. While still damp, layer it with horizontal washes of burnt sienna, cobalt blue, and mauve. Finally, add darker values of these colors to the distant horizon.

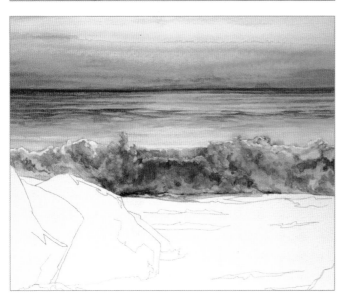

Step 4 Begin working the top portion of the breaking surf where it is catching the most sunlight. Paint pale washes of Naples yellow overlaid with burnt sienna and scarlet lake. Most of the crashing surf is void of direct sunlight, so paint it with cool washes of cobalt blue, mauve, cobalt green, and burnt sienna.

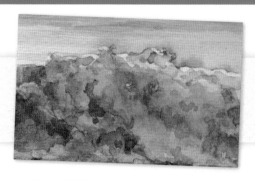

Wave Detail Working small areas and using a wet-into-wet wash establishes the turbulent surf.

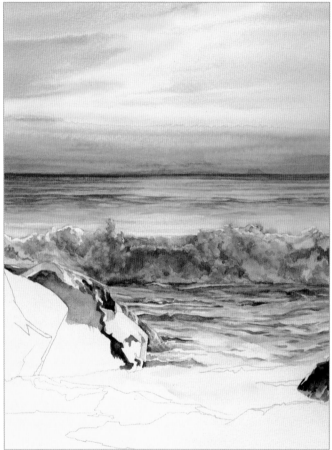

Step 5 To capture the sun's warm glow on the water, use a round brush and paint a wet-into-wet wash of Naples yellow over the entire water area in the cove. Immediately follow this with small touches of burnt sienna and scarlet lake. Once the initial wash is dry, brush in wavy strokes of various blues, greens, and violets to establish the action and patterns of the smaller waves. The area right in front of the crashing surf is in the shade and calls for washes of cobalt blue and mauve.

Tip

A lot of watercolorists become disappointed when colors turn "dirty" from overworking wet-onto-wet strokes with multiple colors. Creating clean yet complex colors is not a one-time process, and getting the proper effect will require patience and multiple layers of color. For this project, it might bode well for the budding watercolorist to practice these rocks on another sheet of paper before adding them to the actual painting.

Rock Detail Notice that the rocks are given structure by layering one wash of color over another. Begin the layering with lighter colors first.

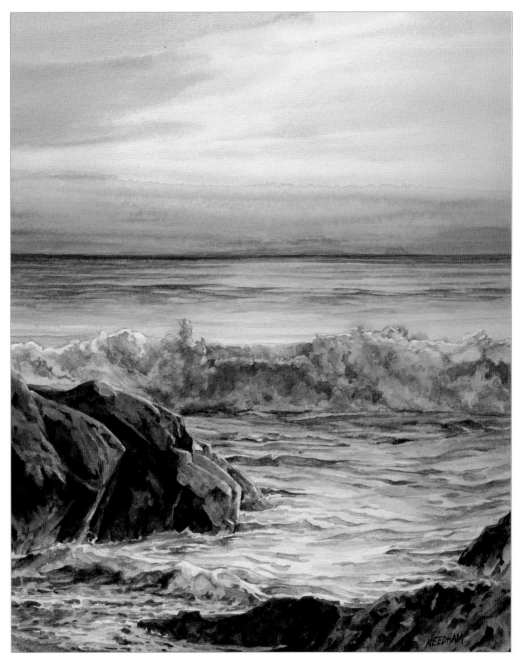

Step 6 Paint the rocks with values and shapes that give them an organic structure. Pay particular attention to the way the sun casts shadows and reflections. Layer colors such as burnt umber, Naples yellow, and burnt sienna as you see fit. To intensify the sun's golden glow on the rocks, add a medium transparent wash of burnt sienna over the lighted surfaces. Finally, darken the value of the distant waves. Scan your painting to see if anything needs enhancement.

PAINTING FROM A DIFFERENT ANGLE

Piers are terrific subjects to paint because they provide artists with a unique point-of-view. In this reference photo, we gaze out from beneath Southern California's Redondo Beach Pier into the fading light. As an artist, I was intrigued by the positive and negative shapes and contrast between light and dark areas.

Palette
burnt sienna, burnt umber, cadmium red, cerulean blue, cobalt blue, cobalt turquoise, Naples yellow, permanent mauve, permanent rose, ultramarine blue

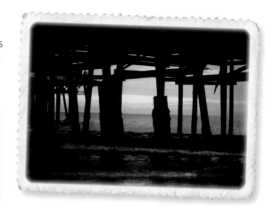

Step 1 Make a detailed line sketch of the scene. To keep your line work crisp use a straight-edged instrument such as a triangle or ruler for the boards, planks, and pilings.

Tip
Do not shake the bottle of masking fluid prior to use. Stir the fluid gently. Otherwise, you'll produce air bubbles in the fluid, which can leave potholes in the mask and unwanted spots of color on your paper.

Step 2 Next, apply masking fluid below the horizon line in a one-inch strip, and then apply it over everything above the horizon line that is not sky. Since I use a clear masking fluid, I have highlighted the masked areas in green for your reference.

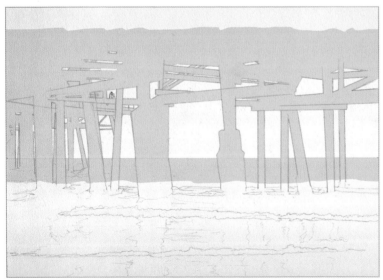

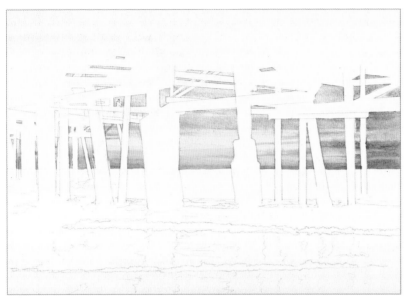

Step 3 When the masking fluid is completely dry we are ready to begin a wet-into-wet wash for the sky. Use a one-inch flat brush and apply clean water to the entire sky area. Using the same brush, apply horizontal strokes of Naples yellow. Working rapidly, switch to a round brush and apply a small amount of permanent rose along the horizon line. Add a pinch of burnt sienna just above the permanent rose. Next, layer cerulean blue onto the upper portion of the sky. Paint in the clouds using a mix of permanent rose and cerulean blue. When you are finished, remove the masking.

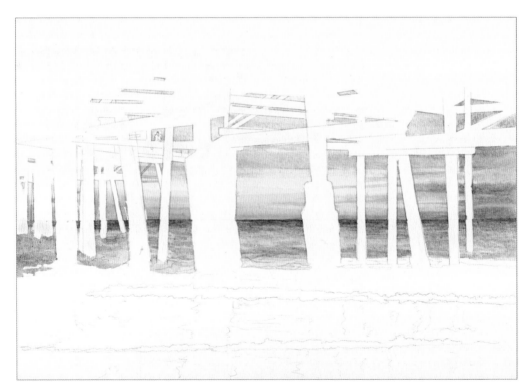

Step 4 Mask off the pilings from the horizon line to the top of the back wave. Once the masking is dry, we are ready to execute a wet-into-wet wash for the ocean. Begin with a light layer of Naples yellow and touches of permanent rose over the entire ocean area. Next, add a light wash of cerulean blue. While the paper is still damp, add some ultramarine blue along the horizon line and distant ocean. Then remove all the masking.

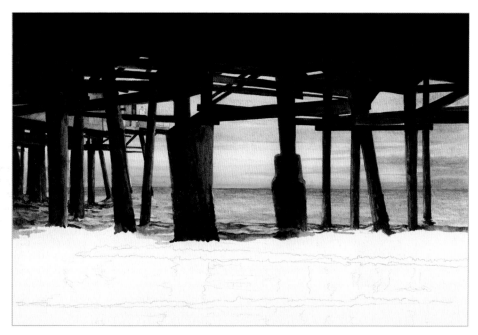

Step 5 With the exception of the building and two people at the end of the pier, this portion of the painting is in silhouette. Use touches of burnt sienna and permanent rose where the sun's glow hits the edges of the pilings. For the deep, dark, shadow areas apply large amounts of ultramarine blue, permanent mauve, and burnt umber. Apply vertical washes of cerulean and ultramarine blue to the partially visible building on the pier. Remove all masking.

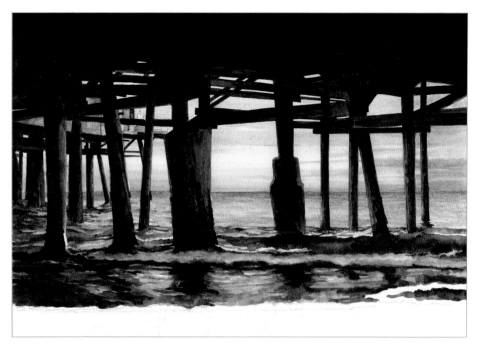

Step 6 Now paint the back waves in the shadow area using a wet-onto-dry wash. Leave the top edges of the waves white for now. Using a round brush, lay in washes of dark blues and purples where the waves are in shadow. Where the small wave is breaking, paint with washes of cerulean and cobalt blue. Once the shadow areas of the waves are dry, come back over the top edges that remain white with light washes of Naples yellow and permanent rose.

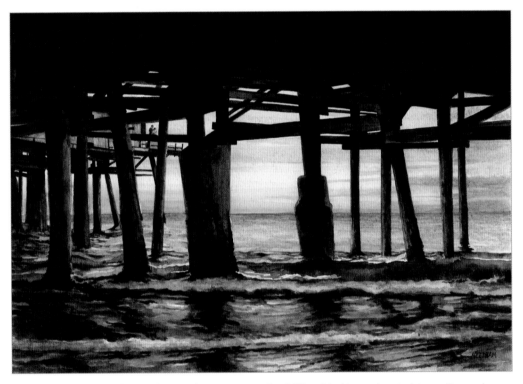

Step 7 Continue rendering foreground waves in the same manner as Step 5. Where light shines on the water between pilings, apply a base wash of Naples yellow and permanent rose. Next, layer various washes of blues. Be sure to let some of the base wash come through where light is reflecting off the water. Finally, using a thin brush, carefully paint the two people standing on the end of the pier.

RENDERING SMALL DETAILS

This painting explores various elements and themes found in seascapes: sky, sea, rocks, and wildlife. Using masking techniques, we will pay close attention to the small details, such as the white of the seagulls' feathers and the spray coming off the rocks.

Palette

burnt sienna, burnt umber, cerulean blue, cobalt blue, cobalt green, cobalt turquoise, mauve, ultramarine blue, yellow ochre

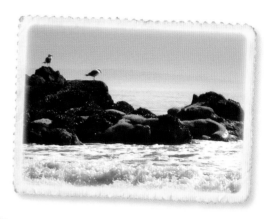

Step 1 Create a drawing with emphasis on the scale of various components and shapes in the reference photo.

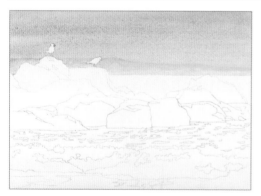

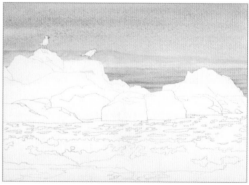

Step 2 Mask out the seagulls and tops of the rocks where they protrude above the horizon; then lay down masking fluid in a one-inch strip below the horizon line. In an effort to warm the temperature of the sky, I begin a gradient wash by adding a touch of yellow ochre near the horizon. The next color is cerulean blue in the center of the sky, followed by overlapping horizontal strokes of cobalt blue at the top of the sky. When the sky is thoroughly dry, I add a subtle coastline by applying a slightly darker blue using a wet-onto-dry approach. When the sky is thoroughly dry, remove the masking material.

Step 3 Mask off the rocks where they come in contact with the ocean. Once the masking is dry, use a round brush and proceed with a wet-into-wet wash, painting the ocean with various values of ultramarine, cobalt, and cerulean blues and cobalt green. Use darker values to indicate distant waves. Remove all masking fluid when dry.

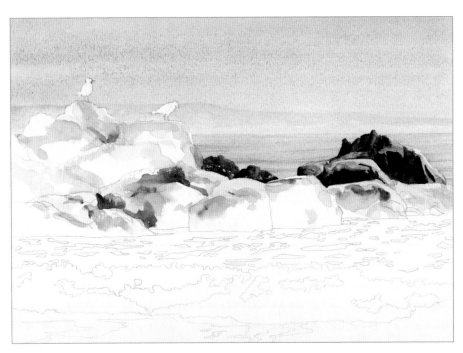

Step 4 First, mask off tiny speckles of the sun's reflections and mussels found on the rocks. When the masking is completely dry, begin layering in various colors, incluing yellow ochre, burnt umber, burnt sienna, ultramarine, cobalt, and cerulean blues, mauve, cobalt turquoise, and cobalt green. Working from light to dark, methodically layer one color over another to build structure into the rocks.

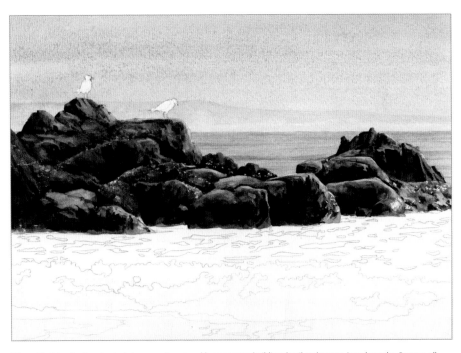

Step 5 Using the layering technique, continue to add more tones, building detail and texture into the rocks. Remove all masking fluid when dry.

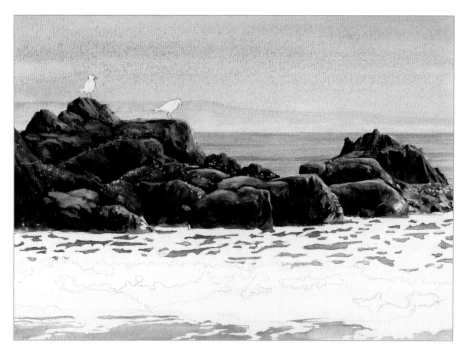

Step 6 Next, we'll work the sea foam area between the rocks and the rushing surf. Apply masking fluid to the white lacy pattern of the sea foam and top of the surf. Once the masking is dry, apply washes of various blues over the foam area and add a dab of burnt sienna near the rocks. When the wash is dry, remove the masking and throw a light wash of cerulean blue over the lacy pattern to soften the bright white of the foam.

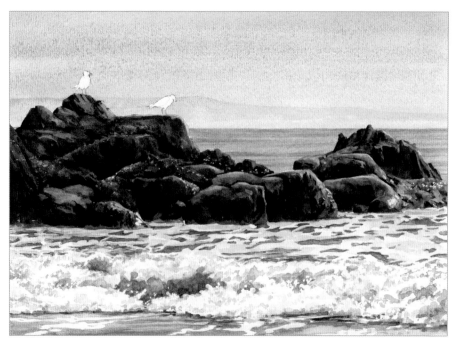

Step 7 Mask areas of the surf and some specks of splash. Paint in small areas working both wet-into-wet and wet-onto-dry. Using subtle value changes of light blues, violets, greens, and umber, give the surf some action and structure.

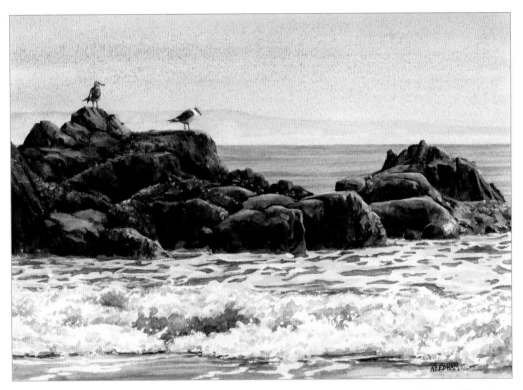

Step 8 Carefully render the seagulls with a thin round brush. Mix shades of gray using blues and burnt umber. Add a mix of yellow ochre and burnt umber for their legs and beaks. Finally, use a touch of white gouache on the bright areas of their heads and chests. White gouache can also be used to create small specks of spray from the rushing surf.

Wave Detail Notice the very subtle value changes in the surf. It is these very slight value changes that give the surf action and believability.

Bird Detail Render the seagull's body using various shades of gray and thin, round brushes.

MIXING REFERENCES & IMAGINATION

As a teenager I fished off a barge moored a few miles off the Redondo Beach Pier in Southern California. At day's end, a boat would come and return us back to the pier. I was always amazed at the number of seagulls that trailed our boat back to the dock in hopes of snagging some of our leftover bait. Using elements from both the reference photo and my imagination, I tried to capture a similar scene in this painting: a lone fishing boat returning with the day's catch, trailed by seagulls, and a setting sun glittering on the ocean.

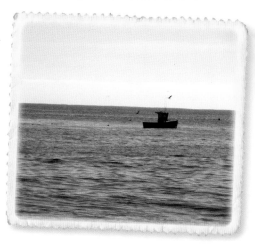

Palette

burnt sienna, burnt umber, cadmium orange,
cerulean blue, cobalt blue, Naples yellow,
scarlet lake, ultramarine blue, yellow ochre

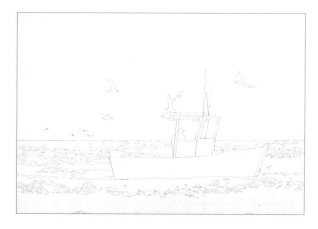

Step 1 Create a sketch of the photograph with emphasis on the placement and scale of the boat and seagulls. Add small, random shapes to the ocean to suggest sun sparkles reflecting off the water. With the exception of the seagulls, the sky is left empty.

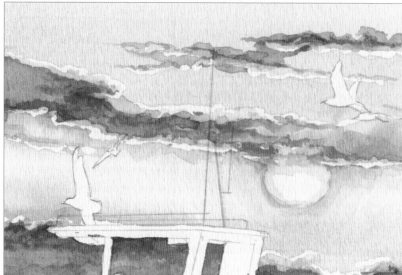

Step 2 Begin by masking the seagulls, the cabin portion of the boat, and about one inch of ocean below the horizon line. Using your creativity, use the masking to add some clouds as well. (I do not mask all of the clouds—only their rim-lighted edges.) Finally, mask a disc for the sun.

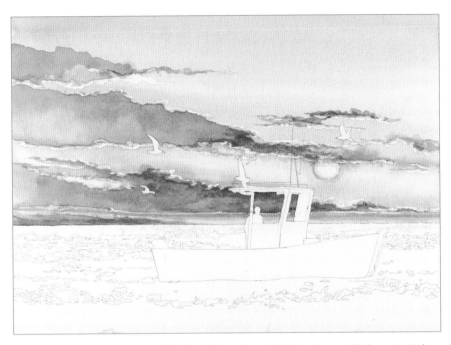

Step 3 Once the masking is dry, use a flat brush and thoroughly wet the sky's surface area with clear water. Work rapidly, applying a mix of Naples yellow and yellow ochre near the horizon. Next, mix cobalt and cerulean blue. Start at the top of the sky and work down horizontally to the middle of the wash. Add a dab of scarlet lake in the center of the wash and allow it to blend towards the blues and yellows. Continue laying in clouds using yellow, orange, burnt sienna, and touches of scarlet. For grayer cloud areas, use mixes of cobalt and cerulean blue along with burnt sienna and scarlet. Once everything dries, remove the masking and finish the sky by coming back over the cloud edges with light washes of orange and yellow, making sure to leave some white.

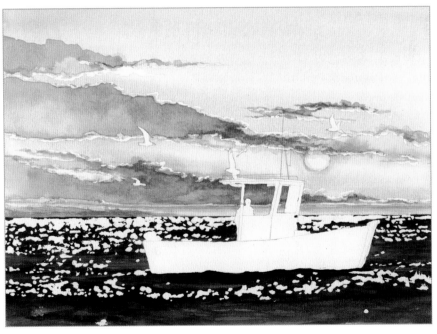

Step 4 Mask out the boat and sun sparkle shapes on the ocean. Once the masking is dry, mix a puddle of color big enough to cover the ocean. The colors I used are ultramarine blue, cobalt blue, cerulean blue, and scarlet lake. Apply a wash over the entire ocean area with a round brush.

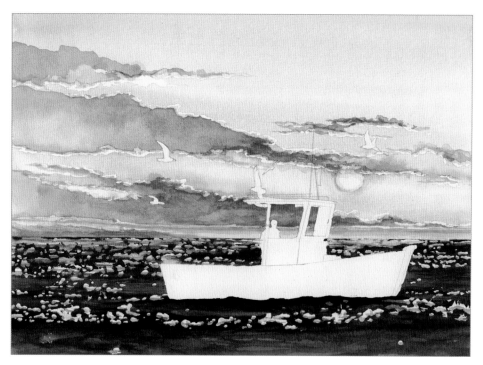

Step 5 When the ocean wash is completely dry, remove all masking from the painting. Using a round brush, gently stroke a light wash of yellow ochre and cadmium orange over some of the sun sparkles reflecting off the water, leaving a few of the sparkles pure paper-white.

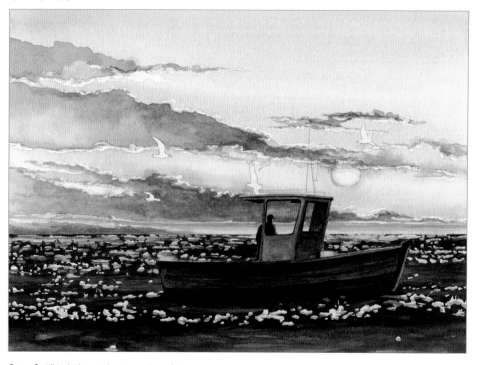

Step 6 Fill in the boat with various values of ultramarine blue, cerulean blue, burnt umber, and touches of scarlet lake.

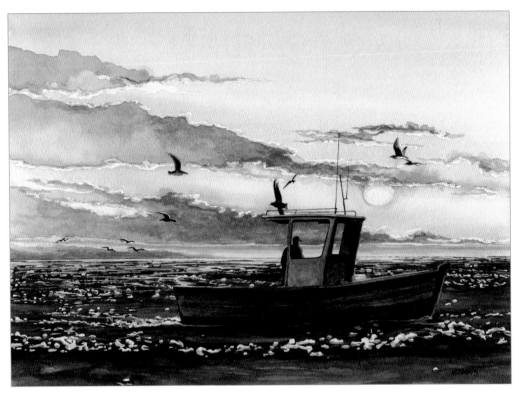

Step 7 Using a round detail brush, render the seagulls with various values of blues and burnt umber. Carefully paint the radio antennas and boat railing and add a few brushstrokes of scarlet lake to the ocean. Using white gouache mixed with yellow ochre and cadmium orange, add glints to the ocean where needed.

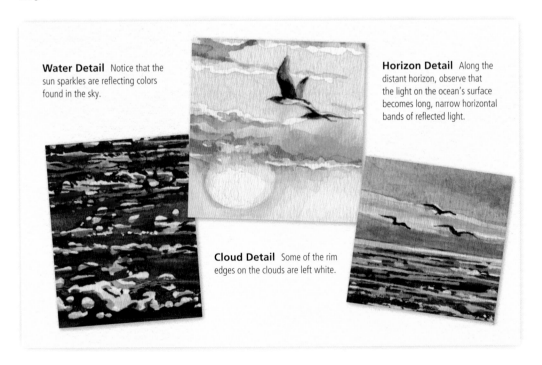

Water Detail Notice that the sun sparkles are reflecting colors found in the sky.

Horizon Detail Along the distant horizon, observe that the light on the ocean's surface becomes long, narrow horizontal bands of reflected light.

Cloud Detail Some of the rim edges on the clouds are left white.

ADDING SHADOWS

I love painting lighthouses. These trusty beacons are captivating, for they are full of history and they nudge ships away from danger. My reference photo of the Monhegan Island Lighthouse on Maine's coast was snapped during the day. Although it's beautiful, it's not all that exciting. I want to add some drama and mystery to the scene, so to accomplish this, I painted the reference as a night scene with a full moon breaking through the clouds.

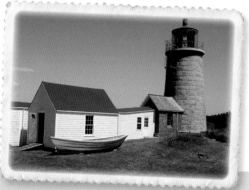

Palette

alizarin crimson, cerulean blue, burnt sienna, burnt umber, Indian red, Indigo blue, lemon yellow, Payne's gray, ultramarine blue, Winsor violet

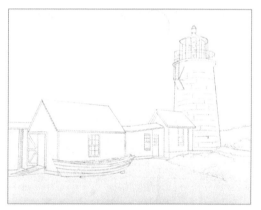

Step 1 When incorporating structures into a painting, it is important to have a detailed drawing. In order to avoid pencil marks, it is best to work out the details of the composition before committing the drawing to the painting surface. With the details of the composition worked out, I transfer a contour line drawing to my painting surface using a 2H pencil.

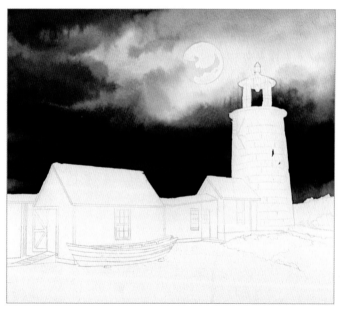

Step 2 Mask all of the structures that protrude into the sky and the portion of the moon that is to remain white. Lay in the sky using a wet-into-wet variegated wash consisting of lemon yellow, cerulean blue, Winsor violet, Indigo blue, and Payne's gray. Begin the wash by wetting the entire sky surface area. Next, brush a small amount of lemon yellow around the moon to give it a bit of a glow. Working rapidly, lay in small amounts of Winsor violet and cerulean blue near the moon. Paint the clouds with heavy amounts of Indigo blue and Payne's gray. Remove the masking when the sky is completely dry.

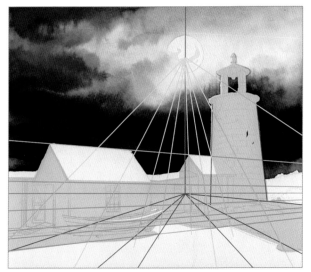

Step 3 This step is quite challenging, so make sure you take it slowly and be patient with yourself. Before rendering the lighthouse and buildings, it is helpful to know where the shadows are going to fall. Our scene is backlit with the moon relatively low in the sky, which makes painting the shadows somewhat challenging. To determine the shadows, I first need to establish eye level: this is the gold horizon line. Then, from the center of the moon, I draw a vertical magenta line that intersects with the gold horizon line. The point where these two lines intersect is called the shadow vanishing point (SVP). Draw light-blue light rays from the moon's center to the roof edges and onto the ground. From the SVP, draw magenta lines to the light blue lines. Where the light blue lines intersect with the SVP lines on the ground is the length and direction of the shadow. Draw the outline of shadows lightly.

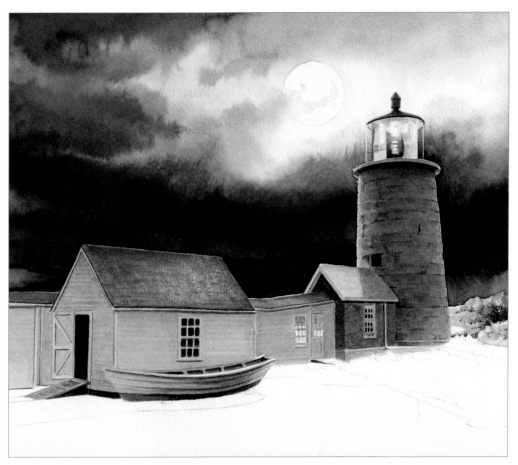

Step 4 Add the following colors to your palette: burnt umber, burnt sienna, Indian red, and alizarin crimson. Using the layering technique, render the larger surface areas such as roofs and building sidings. To obtain the proper value, a number of layered washes will be required to build a rich tone. You can add highlights on the roofs using a wet cotton swab. Gently rub it on the roof area, removing just a tad of pigment.

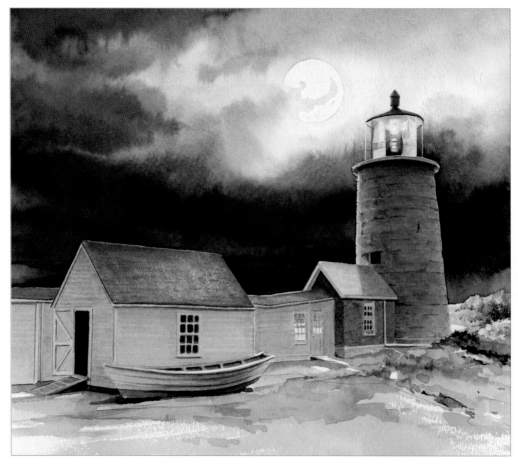

Step 5 Mix some Indigo blue with burnt umber and brush in a basic ground color. Keep the ground generally light so it will contrast dramatically against the shadows. Add a little Payne's gray into the mix to add some darker values.

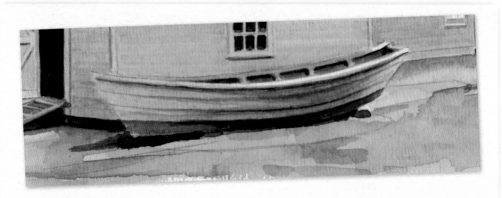

Boat Detail To give the illusion of a bright, full moon, remember to add cast shadows to the elements in your scene (such as the boat and lighthouse tower) while keeping in mind the direction of light.

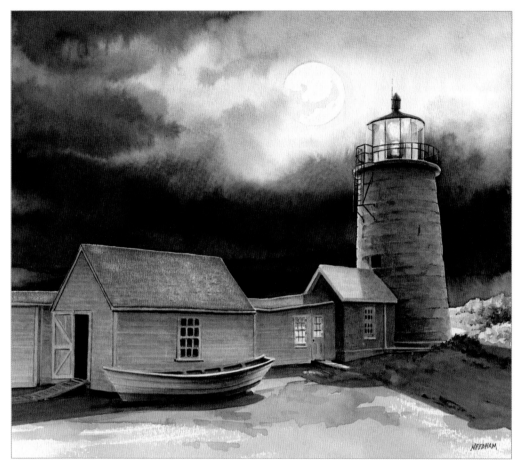

Step 6 Lay in the shadows using a mix of Indigo blue and Payne's gray. Adjust the values on the lighthouse and sides of the buildings so they are dark enough to be dramatic. Add some final touches on the lighthouse by painting in the ladder and railings. Add a touch of white gouache to the center of the lighthouse light to make it even brighter.

Moon Detail Keep the shapes within the moon simple and crisp.

Building Detail The warm glow of interior lights through the window gives this building life.

OMITTING THE UNNECESSARY

The goal of this project is to paint the late afternoon glow captured at Point Mugu, California. Although it poses a challenge, capturing the afternoon light on the cliffs and the reflection of the sky on the wet sand is enjoyable. For this particular painting, I omitted the left side of the reference photo because of the blinding sun.

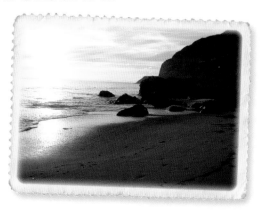

Palette
alizarin crimson, burnt sienna, burnt umber, cerulean blue, cobalt blue, lemon yellow, mauve, Naples yellow, ultramarine blue

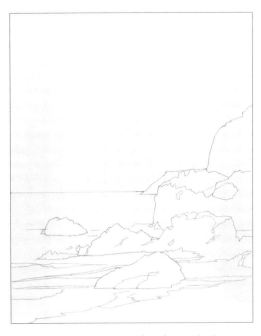

Step 1 Pencil in a line drawing with emphasis on the placement of the cliffs and rocks.

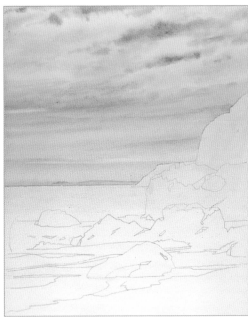

Step 2 First, mask off the ocean and cliffs. Using a wet-into-wet variegated wash, rapidly apply Naples, lemon yellow, and burnt sienna near the ocean's horizon line. Next, use a round brush to paint the top part of the sky using mixtures of cerulean and cobalt blue. Add some grays to the bottom of the clouds with mixtures of cerulean and cobalt blue and Naples yellow. Add touches of burnt sienna and mauve to the bands of distant clouds. Remove all masking.

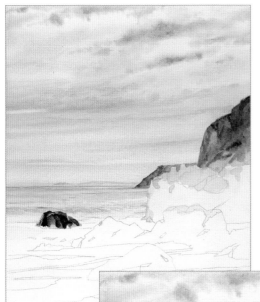

Step 3 Lay in the distant ocean using lemon, Naples yellow, and burnt sienna. The initial wash for the ocean can be wet-into-wet. Once the ocean is dry, layer very light horizontal washes of cerulean, mauve, and burnt sienna. Then paint the cliffs using the layering technique, starting with a Naples yellow. Once dry, add burnt sienna. When the second layer dries, add a mix of lemon yellow and cerulean. Continue the process until you are achieve a warm, rich glow.

Step 4 Fill in the rocks in the middle using lighter values of alizarin crimson and Naples yellow. To add structure and texture, slowly and methodically layer mixtures of burnt umber and ultramarine blue over the initial washes of crimson and yellow.

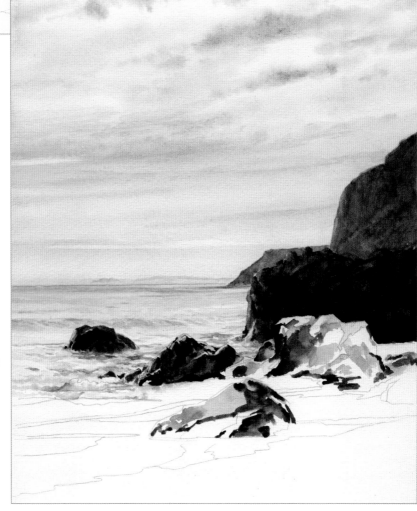

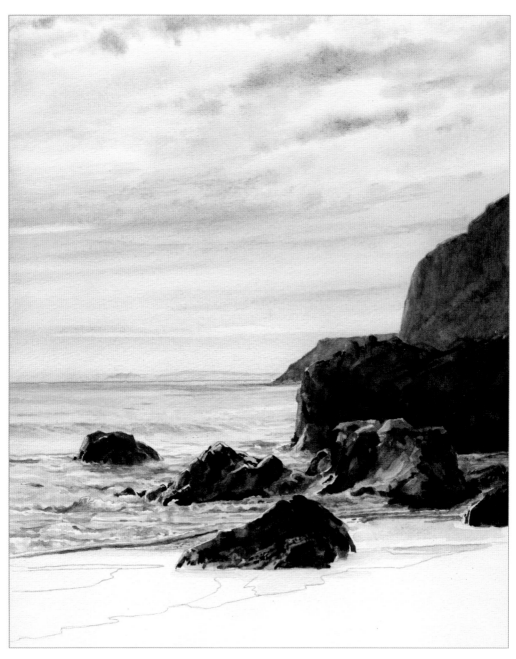

Step 5 Using a round brush and wet-onto-dry technique, add the surf around the rocks. Apply some light washes of Naples yellow first and then add various shades of cerulean blue, cobalt blue, and mauve. Give the surf a shadow where the edge meets the sand.

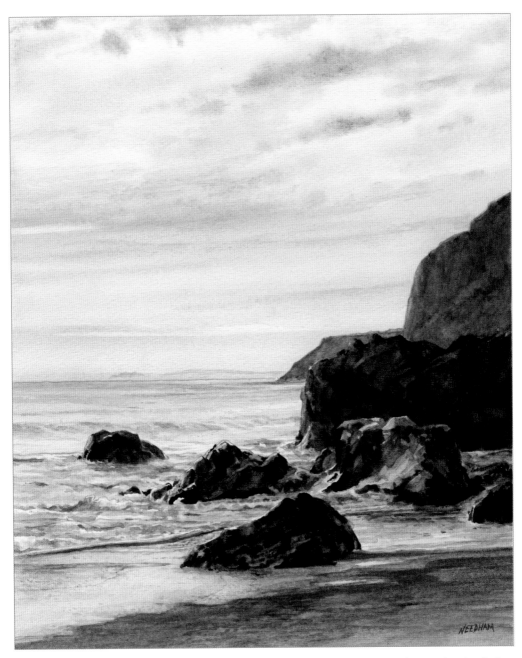

Step 6 Working from light to dark, paint the wet sand with a light wash of Naples yellow, burnt sienna, and mauve. Where the reflective sand ends and the damp sand begins, paint a wash of burnt umber and cerulean blue to the edge of the painting. Continue to add more washes for the darkest sand below the rocks with variations of burnt umber, ultramarine blue, cerulean blue, and mauve.

RENDERING THE COASTLINE

Just south of Point Mugu along California's famed Pacific Coast Highway, the sun's rays bounce across the sea and splash onto the cliffs of the surrounding coastline. I chose not to alter much from the reference photo; I like how the hills, coastline, and waves all lead the eye to a point in the distance. You'll find that the real challenge here is using watercolor to capture the scene's almost surreal golden glow.

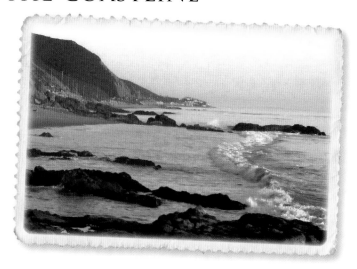

Palette

burnt sienna, burnt umber, cerulean blue, lemon yellow, mauve, permanent rose, raw sienna, scarlet lake, ultramarine blue

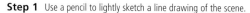

Step 1 Use a pencil to lightly sketch a line drawing of the scene.

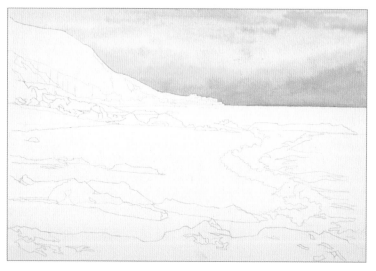

Step 2 Start by masking off the hill and distant ocean. Begin a wet-into-wet wash with a layer of clean water over the entire sky area. Next, brush a coat of raw sienna from the horizon line to mid-sky. From here, introduce permanent rose and then add cerulean blue near the top. Using a round brush, finish the sky by adding a few clouds. For the lighter colored clouds, use a mix of raw sienna, cerulean blue, and permanent rose. For the darker clouds, use mixtures of raw sienna, permanent rose, and ultramarine blue. After the wash has dried, remove all masking.

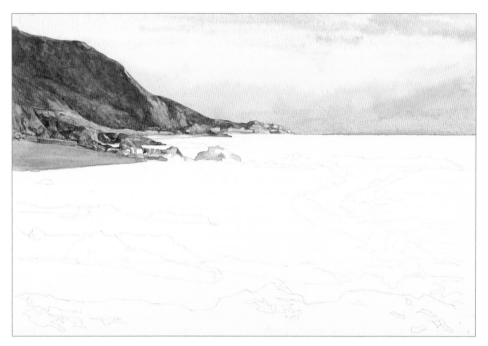

Step 3 First bathe the cliffs in lemon yellow followed by a wash of scarlet lake mixed with lemon yellow. Next, add a wash of cerulean blue and raw sienna over the vegetation on the hillside.

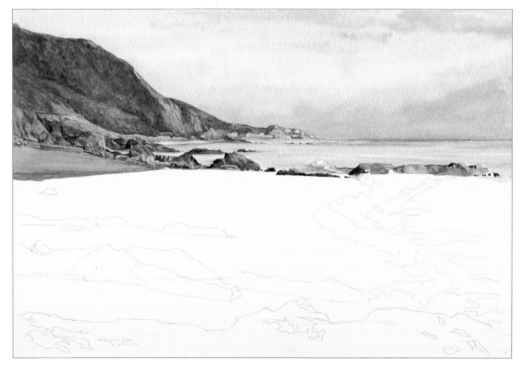

Step 4 Begin painting the ocean using a light wash of raw sienna. Follow this with light, horizontal strokes of permanent rose. Once the initial wash has dried, come back over it with a wet-onto-dry technique using light touches of cerulean blue and a few strokes of permanent rose and ultramarine blue.

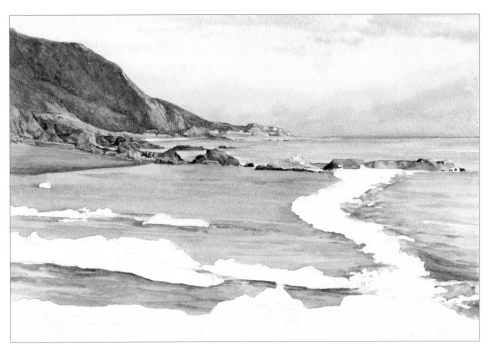

Step 5 Mask out the foreground rocks and crashing wave. When the masking fluid is completely dry, begin a wet-onto-dry wash using dark values of raw sienna, permanent rose, cerulean blue, and ultramarine blue. On the left side of the wave, your brushstrokes should appear to "pull" from the beach to the wave. To depict turbulence, sculpt the back of the wave with stronger and darker values. When the washes are dry, remove all the masking.

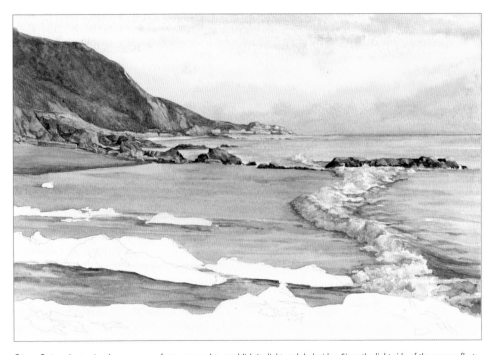

Step 6 In order to give the wave some form, we need to establish its light and dark sides. Since the light side of the wave reflects warm colors from the late afternoon sun, use a light wash of permanent rose and a mix of scarlet lake and lemon yellow. On the shady side of the wave, use a wash of cerulean blue mixed with permanent rose.

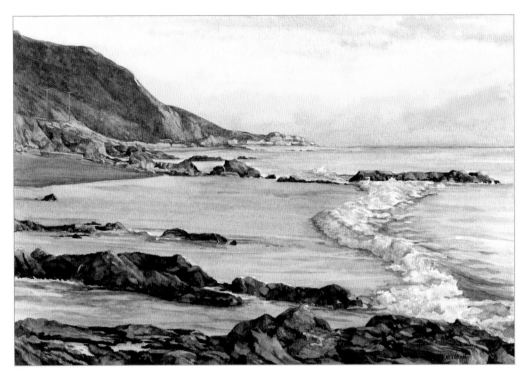

Step 7 First, paint the foreground rocks with lighter colors. Next, build structure into the rocks by adding darker values. Use a myriad of colored washes, layering one over another to obtain subtle changes. If you'd like, use a mix of white gouache and scarlet lake to paint the telephone poles.

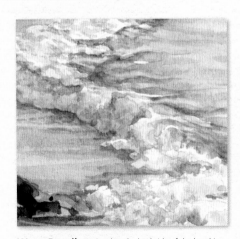

Wave Detail Notice that the backside of the breaking wave is painted with warm colors from the setting sun.

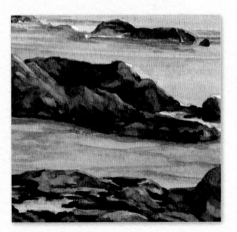

Rock Detail Observe that the surfaces on the rocks that face the sun are a warmer and lighter value.

43

PAINTING FROM IMAGINATION

For many a beachgoer, the definition of perfection is a day spent along the ocean's edge. From the throne of a beach chair, one can view the edge of the world and fill the senses with fresh air, the roar of the ocean, and the warmth of the sun. I did not use a photo reference here; I pulled the sky, sand, and sea from my imagination.

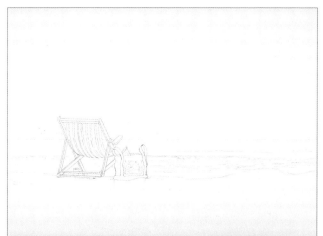

Step 1 Sketch a line drawing of a beach chair, bag, soda can, and the horizon line.

Palette

burnt sienna, burnt umber, cerulean blue, cobalt blue, cobalt turquoise, Naples yellow, permanent rose, raw sienna, sap green, scarlet lake, ultramarine blue, white gouache

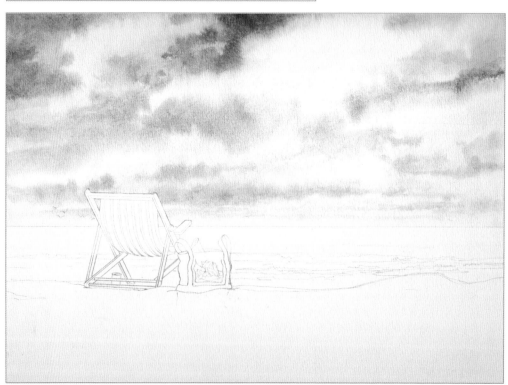

Step 2 Start by placing masking fluid over the top portion of the beach chair and below the horizon line. Once the masking is thoroughly dry, wet the entire sky area with a very light wash of raw sienna. Next, apply a wet-into-wet variegated wash using a round brush. Starting at the top, spread a mixture of ultramarine and cerulean blue over the sky, painting around the clouds. As you move toward the horizon line, use more cerulean and less ultramarine. Finally, add a wash of cerulean, burnt umber, raw sienna, and ultramarine to the clouds to give them form. When you are satisfied with your sky, allow it to dry and then remove the masking.

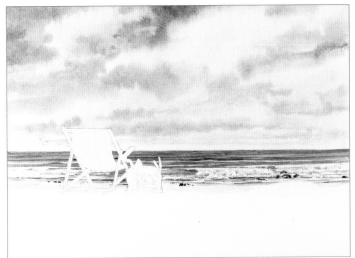

Step 3 Next, we'll work on the ocean. Begin by masking out the beach chair and bag. Using a round brush, apply a wet-onto-dry wash of ultramarine blue, cobalt turquoise, and burnt umber. Use darker values near the horizon and progressively lighter ones as the sea comes closer to the shore. To indicate waves, paint dark, horizontal lines in the distance using a round brush. For the splash area of the breaking waves, use subtle value changes of blues and grays. Using burnt sienna, burnt umber, and ultramarine blue, add a few rocks to the shoreline. Remove all masking.

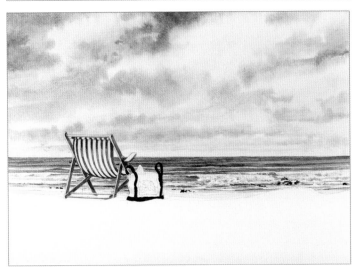

Step 4 Using a round brush, paint in the stripes of the beach chair with scarlet lake. The black straps on the book bag can be rendered using a mix of ultramarine blue and burnt umber.

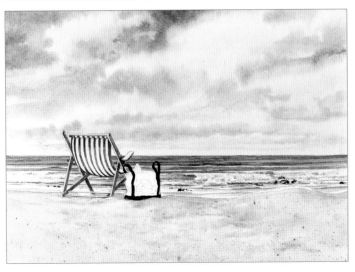

Step 5 Cover the entire sand area with Naples yellow, raw sienna, burnt umber, and a pinch of cerulean blue. Cover the sky and sea with a paper towel. While the sand is still damp, load a toothbrush with burnt umber. Using your thumb or finger, flick the bristles of the toothbrush to produce tiny droplets of paint, giving the sand some texture.

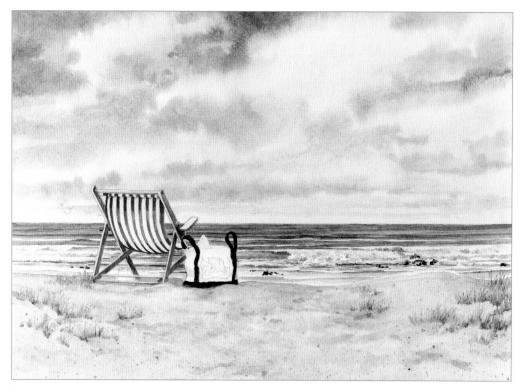

Step 6 Apply small amounts of water to the areas where you want to render grass, and then add raw sienna, burnt sienna, sap green, and ultramarine blue to the same areas. Use a craft knife to scratch the surface rapidly, producing tiny blades of grass.

Grass Detail The values of the blades of grass can be controlled by the dampness of the paper; the wetter the surface, the darker the color.

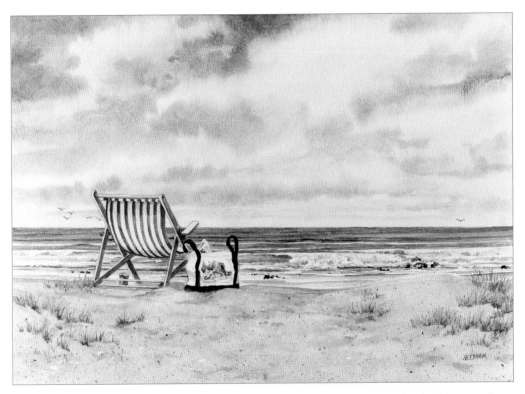

Step 7 For the final detail work, use thin round brushes to render the soda can and design on the bag. Finish up by adding some gulls to the sky and a few blades of grass where necessary.

Chair Detail Give the chair dimension and structure through the use of light and dark values.

Cloud Detail Soft edges for clouds are best obtained using wet-into-wet washes.

CHANGING THE SCENERY

Not every day is a "day at the beach." I recall days out on the water that started off picture-perfect and calm but turned into an amusement park ride by late afternoon. Let us paint such a day. The following painting depicts a sailboat and its crew returning to port, challenged by a rough ocean.

Palette

cobalt turquoise, Hooker's green, lemon yellow, Payne's gray, permanent rose, raw sienna, scarlet lake, ultramarine blue, white gouache

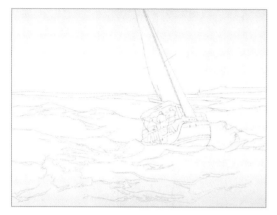

Step 1 Using a 2H pencil, produce a line drawing of the composition. I use a photo reference for the sailboat and my imagination for the rest.

As a general rule, it is best to work from the background toward the foreground, and to work from the lightest to the darkest colors.

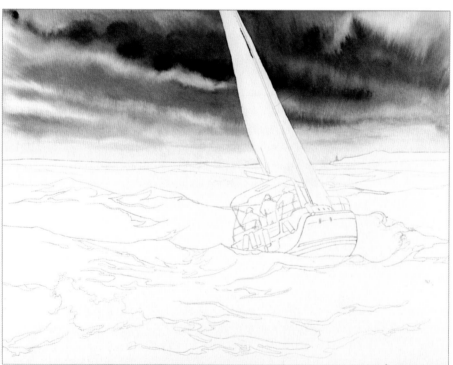

Step 2 Start by laying down a one-inch strip of masking fluid under the horizon line and on the sail where it protrudes into the sky. When the masking is dry, prepare the sky for a wet-into-wet variegated wash by wetting the area with clear water and then a wash of lemon yellow. Working rapidly, add Payne's gray in a slanted direction from right to left. Painting in the same direction, add a healthy amount of Hooker's green. Finish the sky by adding a mix of lemon yellow and scarlet lake near the distant horizon. Remove the masking.

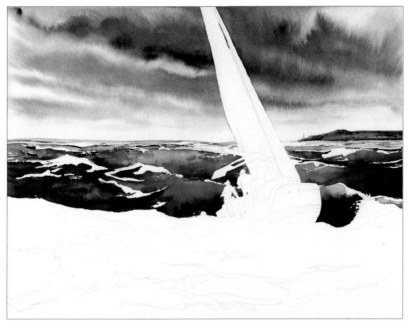

Step 3 Mask the boat and whitecaps on the midground waves. Once the masking has dried, paint the waves using various washes of Payne's gray and Hooker's green. Use lighter values near the top and darker values near the bottom of the waves. Paint the distant coastline with mixtures of permanent rose, gray, green, and yellow. Remove the masking.

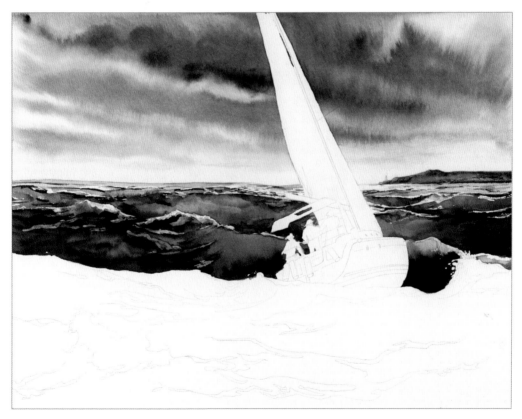

Step 4 Brush light washes of lemon yellow and permanent rose over some of the whitecaps. Apply light washes of Blues and Payne's gray to the shadow side of the whitecaps.

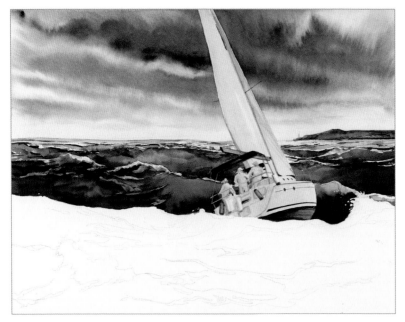

Step 5 Using a round brush, place a light wash of lemon yellow over the entire boat and sail. Next, give the boat some form using Payne's gray. Paint the bottom of the boat with cobalt turquoise. Since weather conditions are stormy, we'll dress the crew in slickers. Yellow slickers work well as a focal point, and the higher color saturation contrasts well with the moody feel of the painting.

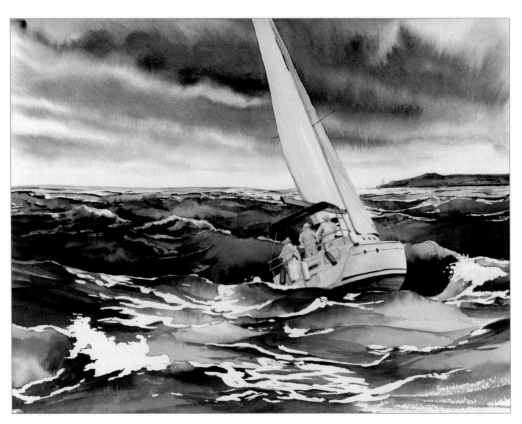

Step 6 Mask out whitecaps and random sea foam patterns. When the masking fluid has dried, use a round brush to paint the waves with mixes of gray and green.

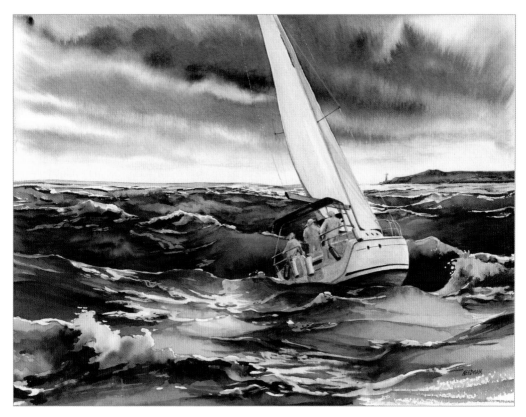

Step 7 Tint the whitecaps and sea foam that are catching light with mixes of yellow and rose. The shady side of the whitecaps and foam can be painted with light washes of gray. Using a thin round brush and a tiny amount of white gouache, carefully add the rigging and railings to the boat. Finish the painting by placing a small lighthouse out on the very distant point of the coastline. Use a speck of permanent rose and white gouache for its beam.

Sky Detail The wet-into-wet technique allows for soft, feathery blends in the clouds.

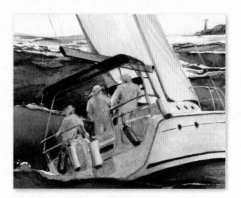

Figure Detail Don't worry about rendering every detail; simply capture the basic shapes and values.

OVERCOMING FEAR

A classic sunset occurs when the sun appears to be resting on the horizon, minutes away from sinking into the ocean. Bands of brightly colored clouds stretch across the sky, painting the ocean beneath them. Rendering scenes such as these without making the colors "muddy" is the ultimate challenge for a watercolorist, but sometimes you just have to go for it. That is precisely what we are going to do with this painting. Now get those brushes out and get to it!

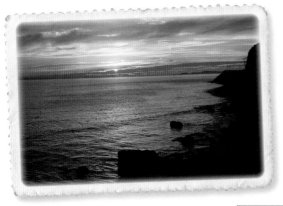

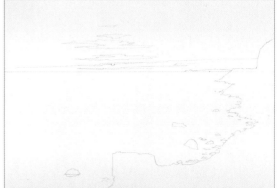

Palette

alizarin crimson, burnt sienna, burnt umber, cadmium orange, cerulean blue, cobalt blue, cobalt turquoise, cobalt violet, lemon yellow, Naples yellow, permanent rose, permanent mauve, transparent yellow, ultramarine blue, white gouache

Step 1 Use a 2H pencil and make a line drawing that includes the horizon line, cliffs, rocks, sun, and clouds.

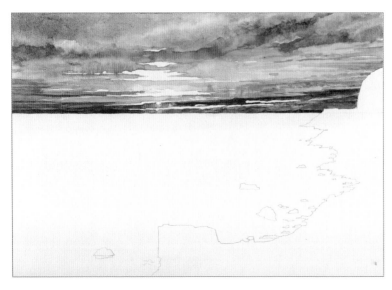

Step 2 Start by laying a one-inch strip of masking below the horizon line and on the cliff that extends into the sky. Next, mask the areas that will eventually be the sun's bright, intense rays. Once the masking has dried, brush clean water over the entire sky area and then lay down a mix of lemon and Naples yellow. Near the bright areas, use stronger amounts of lemon and transparent yellow. Using a round brush, lay mixtures of cerulean and cobalt blue in the upper portion of the sky and then add streaks of cerulean to the mid-sky area.

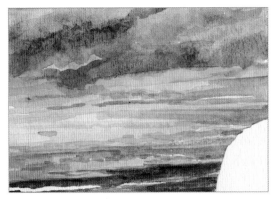

Step 3 Continue to work quickly, layering cerulean, burnt sienna, and permanent rose for a few darker purple clouds in the upper portion of the sky. While painting the various bands of clouds, add streaks of cadmium orange, burnt sienna, and scarlet lake. The bottom bands of clouds include various mixtures of ultramarine blue, permanent rose, scarlet lake, cadmium orange, and burnt sienna.

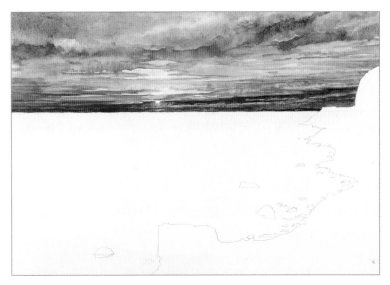

Step 4 Previous masking has preserved the intense, bright areas of the sky. Our task is to blend these areas into their surrounding. Wet the white area with clean water and load a round brush with mixtures of transparent and lemon yellow. Feather the edges that border the white areas with the yellows. Use stronger amounts of pigment near the border edges and let some of the lighter yellow pigment bleed towards the center of the white areas. Leave portions of the white areas clear, especially the center of the sun.

Step 5 Mask the cliffs and rocks in the ocean. When the masking has dried, paint a wet-into-wet variegated wash for the entire ocean using mixtures of Naples yellow, burnt sienna, and permanent rose.

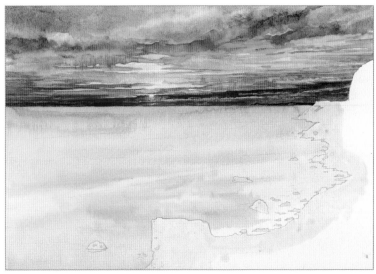

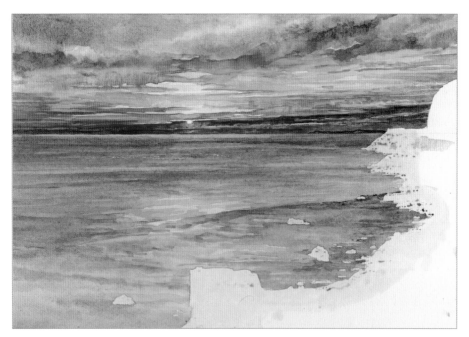

Step 6 Use a round brush and begin to layer various shades of blue and violet near the horizon line. Keep the brushstrokes horizontal and use a wet-onto-dry technique, adding shades of blue and green as you move forward. Use darker values to indicate waves building on the ocean's surface. Let some of the base wash shine through where the sun is reflecting on the sea.

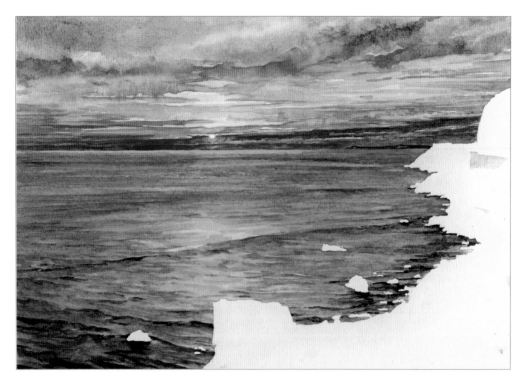

Step 7 Continue to give the ocean form and movement by slowly and methodically layering it with subtle color. Remove the masking from the cliffs and rocks.

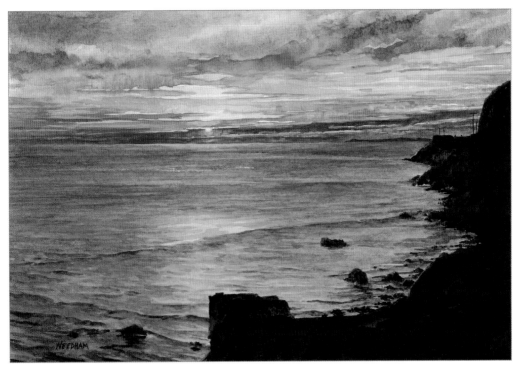

Step 8 For the cliffs and rocks use heavy amounts of ultramarine blue and burnt umber. It will take several applications to reach the proper value. Apply small touches of cobalt turquoise and violet to add richness to the colors in these areas. The darker values will help add form and depth to your painting. Finally, add tiny amounts of burnt sienna and permanent rose to the parts of rock that are catching light.

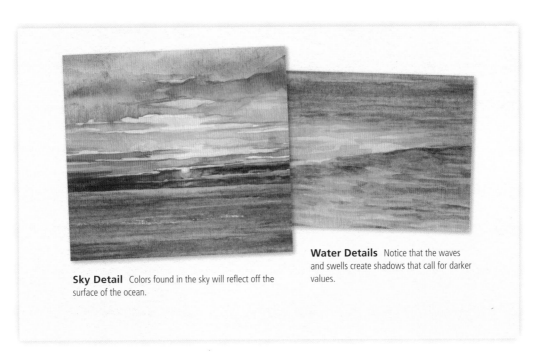

Water Details Notice that the waves and swells create shadows that call for darker values.

Sky Detail Colors found in the sky will reflect off the surface of the ocean.

CAPTURING THE MOMENT

As the sun begins to set, I like to stroll past the snow cone stands, souvenir shops, and restaurants to the end of the Redondo Beach Pier. Aside from being a great place to view breathtaking sunsets, the end of the pier is full of action. It is here that you will find the local fishermen casting their lines and catching their dinner. In this project, we'll paint a scene from this late-afternoon action.

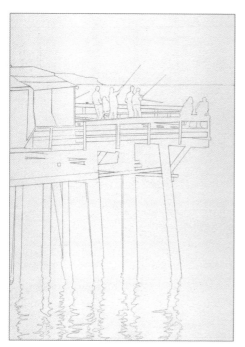

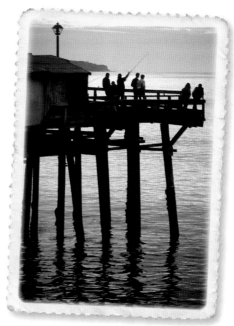

Step 1 Make a detailed line drawing of the scene using a 2H pencil, placing emphasis on an accurate drawing of the pier's structure and people.

Palette

alizarin crimson, burnt sienna, burnt umber, cerulean blue, cobalt blue, cobalt turquouise, Naples yellow, mauve, permanent rose, scarlet lake, ultramarine blue, white gouache

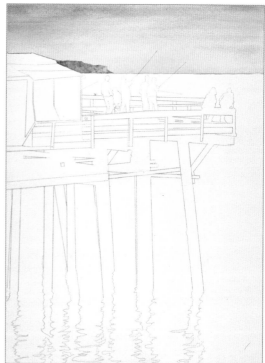

Step 2 Place a one-inch strip of masking fluid below the horizon line and along the roof that protrudes into the sky. Using a one-inch flat brush, apply a wet-into-wet wash over the sky using Naples yellow. Work rapidly with a round brush, adding light amounts of permanent rose and scarlet lake to the horizon line. Mix ultramarine blue with a bit of permanent rose and brush it onto the upper portion of the sky. Let the wash dry and then add scarlet lake and light lavender washes to create the distant shoreline. Remove all the masking.

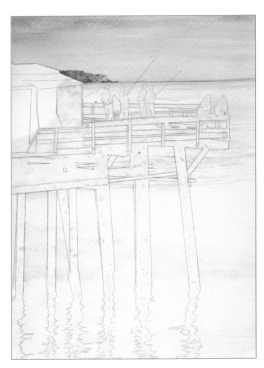

Step 3 Start by masking the pier, the structures on the pier, and the people. Use a one-inch flat brush to spread clean water over the entire ocean. Next, make a wet-into-wet wash over the ocean using Naples yellow and touches of scarlet lake. Work rapidly, adding shades of blue and purple in certain areas, especially near the bottom portion of the painting under the pier. Do not remove the masking.

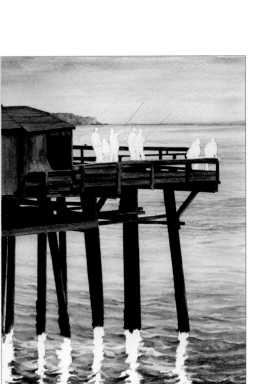

Step 4 Once the previous wash has dried, use a one-inch flat brush to apply a very light wash of cobalt blue over the entire ocean. Next, slowly and methodically build the waves by applying wet-onto-dry washes of various blues over one another. For the very distant ocean, smear a purple-blue wash along the horizon line. Add darker blues and purples near the bottom portion of the painting under the pier. Remove all the masking.

Step 5 Using brushes you are most comfortable with, carefully render the pier and pilings. First, add a light wash of burnt umber and let it dry. Next, add value and temperature with burnt umber, ultramarine blue, and mauve. To capture the sun's reflection on the pilings, add mixtures of scarlet lake and burnt sienna to the edges.

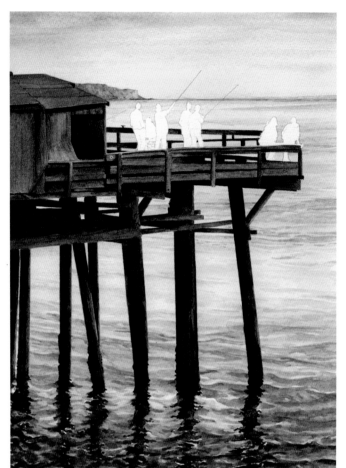

Step 6 Paint the piling shadows with very dark values of ultramarine blue, mauve, and large amounts of burnt umber. To capture the ripples, make your brushstrokes wavy. Add splashes of scarlet lake between the pilings where sunlight is reflected off the water.

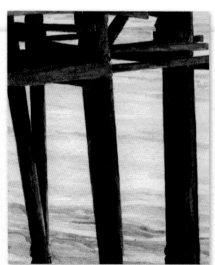

Piling Detail The edges of some of the pilings are lighter and warmer in value, suggesting sunlight.

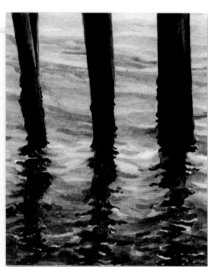

Shadow Detail The bobbing of the ocean makes for piling shadows that appear to be dancing.

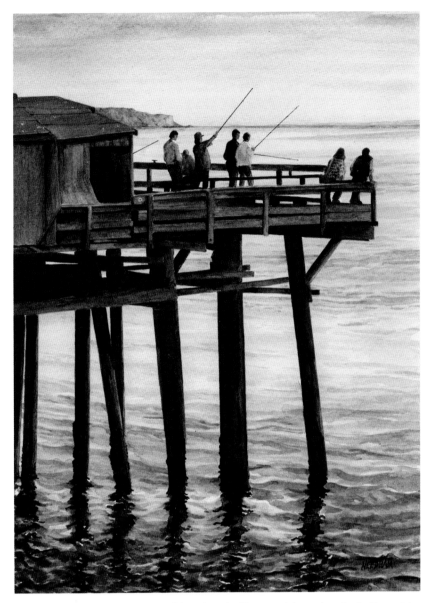

Step 7 We now finish our painting by carefully rendering the fishermen and the people on the pier. To complete this task, use an array of small round brushes. I kept the same amount of people on the pier as in the photo reference but added a few more fishing poles to give the impression of more fishermen than spectators. After completing the people, make one final evaluation of the painting to decide where you can make improvements.

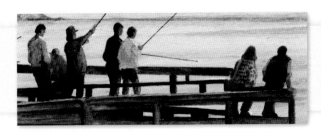

Fishermen Detail The colors on the clothing of the fishermen are lighter than in the reference photo to keep them from looking like silhouettes.

PAINTING IN SECTIONS

This photo captures the kind of summer beach day that Southern Californians anxiously anticipate all winter. Here, five guys are enjoying the fact that one huge breaker is rolling in after another. I improved the mood of the day by using warmer colors and changed the color of the swimwear to add contrast and interest to the painting. I painted wave by wave, layer by layer, section by section. As such, this painting requires lots of masking and patience.

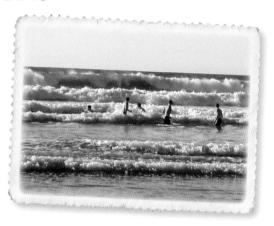

Palette

burnt sienna, burnt umber, cerulean blue, cobalt blue, cobalt turquoise, lemon yellow, permanent rose, ultramarine blue, white gouache

Step 1 Use a 2H pencil and create line drawing of the scene with emphasis on small shapes.

Step 2 Mask a one-inch strip under the horizon line. When the masking is dry, add a gradient wash of cerulean blue to the sky. Remove the masking when the wash is dry. Next, lay down masking along the top of the back wave. Apply a mixture of cobalt turquoise, ultramarine blue, and burnt umber to the distant ocean using a wet-onto-dry technique. Remove the masking.

Step 3 Next, mask along the top of the second wave. Working in small areas, begin to render the most distant wave. Using subtle value changes and a combination of wet-into-wet and wet-onto-dry washes, add a myriad of blues, greens, and yellows to the first wave. Be sure to leave the top part of the wave white.

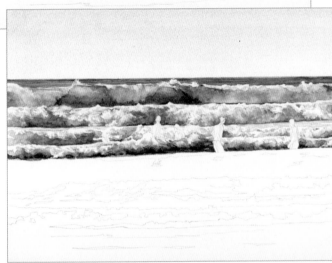

Step 4 Mask the heads of the swimmers and a one-inch strip under the second wave. Render the second wave in a similar fashion as the previous wave. Remove all masking. Next, mask out the five swimmers and render the third and fourth wave in the same manner as the previous waves. Remove all masking.

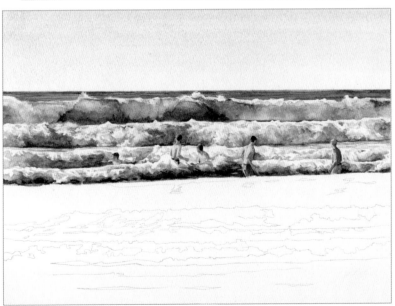

Step 5 Make a flesh tone with lemon yellow and permanent rose. Apply this color to the swimmers using a thin round brush. When the flesh tones have dried, give the swimmers form by adding darker values of burnt sienna and ultramarine blue. Use a mix of ultramarine blue and burnt umber for their hair. Paint their swimwear using bright colors of your choosing.

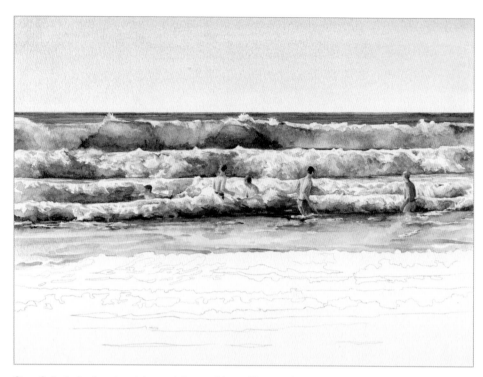

Step 6 Continuing down the painting, mask the tops of the small foreground waves and sea foam in the midground water. Once the masking is dry, use a round brush to apply a wash of cerulean blue. When this dries, come back and add horizontal washes of various blues. Remove all masking and apply very light washes of blue over some of the sea foam.

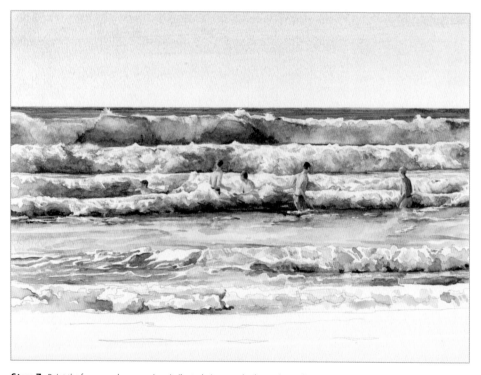

Step 7 Paint the foreground waves using similar techniques and colors as in previous waves.

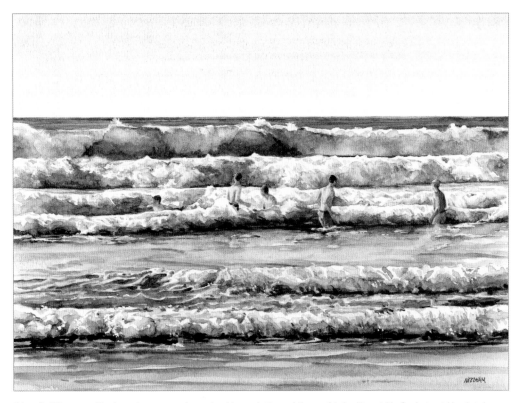

Step 8 Using a round brush, apply a wet-onto-dry cerulean blue wash. Next, add layers of darker blues. Add a few horizontal brushstrokes of burnt sienna near the shadow of the closest wave, and then use various shades of blues and greens to fill in the still water in the foreground. Lastly, add a few specks of white gouache as needed for splash and spray.

Swimmer Detail To give the swimmers' bodies form, be cognizant of where the sunlight is hitting them.

Wave Detail Notice that the tops of the waves are left white and subtle variations of blues are used to give the wave form and shadow.

FINAL THOUGHTS

Seascapes & Sunsets is designed to provide a starting point for the exploration of watercolor as a medium of personal expression and reward. Since this book was written based on my experience and methods that work well for me, I encourage you to develop your own individual style of painting. Techniques alone are not enough to produce the most successful paintings and there are no shortcuts, so you will need a working knowledge of color, value, composition, perspective, and the art of storytelling. The level of success achieved in painting is proportionate to the amount of care and energy invested in it. The quickest way to develop your painting skills is through practice, so use these projects as a guide, be observant, and put lots of mileage on your brush. As your watercolor skills improve, new ambitions and challenges await you on the horizon. Wherever you are in your artistic journey, I hope this book ignites a burning desire to visit some of America's coasts and, more importantly, to paint the sea and sky.

—Thomas Needham

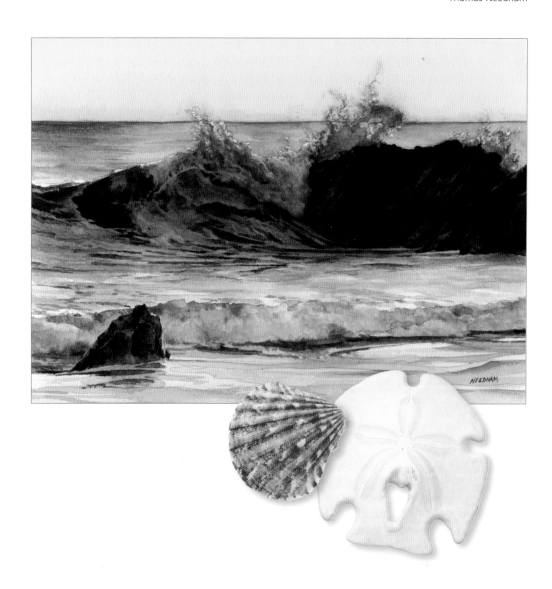